UNDISCOVERED ART
FROM THE KOREAN WAR

EXPLORATIONS IN THE COLLECTION OF CHESTER AND WANDA CHANG

Undiscovered Art from the Korean War

Explorations in the Collection of Chester and Wanda Chang

Paul Michael Taylor | Trevor Merrion | Jasper Waugh-Quasebarth | Robert Pontsioen

Asian Cultural History Program
Smithsonian Institution

This book is produced and distributed by: Asian Cultural History Program, Department of Anthropology, Smithsonian Institution, Washington, D.C. 20560 USA
Design by KI Graphics (Springfield, Virginia, USA). Printed in Korea.

ISBN: 978-1-891739-00-2 (softcover)
First edition.
First printing.

Photographs in this book, unless otherwise noted in the photo caption, are by Chin Kim and provided courtesy of Chester and Wanda Chang. Excepting only photos credited otherwise in the captions, all photographs copyright (c) Chester Chang, who reserves all rights.

Measurements for objects are given in centimeters. Unless otherwise noted two measurements indicate height by width; three measurements indicate height by width by depth.

Korean words in this book are Romanized using the 2000 Revised Romanization of Korean, except in the following cases: 1. for individuals, organizations, firms, etc., who choose to Romanize their own names differently, we use their preferred spellings; 2. for book titles within the Bibliography, we use the U.S. Library of Congress system of Romanization (www.loc.gov) to facilitate locating books, since almost all American libraries use that system. In some cases, following these guidelines can produce more than one Romanization so alternatives are sometimes given in the endnotes.

The authors wish to thank the Korean Cultural Center, especially Dr. Byung Goo Choi (최병구) (Director) and his staff Adam Wojciechowicz and Ji Young Yun (윤지영). Within the Asian Cultural History Program, we thank William Bradford Smith and Adam Simons for their help with the Chang Collection database. Thanks to KI Graphics (Springfield, Virginia) for design and production.

Cataloging-in-Publication Data

Taylor, Paul Michael, 1953- author.
 Undiscovered art from the Korean War : explorations in the collection of Chester and Wanda Chang / Paul Michael Taylor, Trevor Merrion, Jasper Waugh-Quasebarth, Robert Pontsioen.
 — First edition.
 pages ; cm
 "This publication reports on a collection-based research project supported by and carried out in partnership with the Korean Cultural Center, Embassy of the Republic of Korea [Washington, DC]." —Title page verso.
 Includes bibliographical references.
 ISBN-13: 978-1-891739-00-2
1. Art, Korean—20th century—Catalogs. 2. Decorative arts—Korea—History—20th century—Catalogs. 3. Korean War, 1950-1953—Art and the war—Catalogs. 4. Chang, Chester, 1939- —Art collections—Catalogs. 5. Chang, Wanda—Art collections—Catalogs. 6. Art—Private collections—California—Santa Monica—Catalogs. I. Merrion, Trevor Loomis, 1987- author. II. Waugh-Quasebarth, Jasper, 1990- author. III. Pontsioen, Robert, 1978- author. IV. National Museum of Natural History (U.S.). Asian Cultural History Program. V. Korean Cultural Center (Washington, D.C.). VI. Title.
 N7365.T39

한국문화원
KOREAN CULTURAL CENTER
Washington D.C.

This publication reports on a collection-based research project supported by and carried out in partnership with the Korean Cultural Center, Embassy of the Republic of Korea.

The Korean Cultural Center Washington D.C. at the Embassy of the Republic of Korea works in and around the Capital region to promote understanding and appreciation of Korea and its diverse, rich culture.

Contents

PART I KOREAN WAR ART IN THE COLLECTION OF
 CHESTER AND WANDA CHANG 6

 The Smithsonian and the 60th Anniversary of the Armistice:
 Remembering the Korean War 8

 The Smithsonian's Korean Heritage Project and Korean War Art 10

 Dr. Chester Chang, Collector 11

 Undiscovered Art, a Research Resource for Korea's History 13

PART II CATALOG 16

 Lee Jung-seop 이중섭 18

 Kim Kwan-ho 김관호 20

 Park Sookeun 박수근 22

 Hoe Won 회원 24

 Byeon Kwan-sik 변관식 26

 Chu Dang 추당 28

 Ha Eun 하은 32

 Song Mi 송미 34

 Chin Heung Souvenir Plates 35

 Metalworks 38

 Woodwork 47

 Wooden and Ceramic Figurines 50

 Embroidery 54

ENDNOTES 57

BIBLIOGRAPHY 58

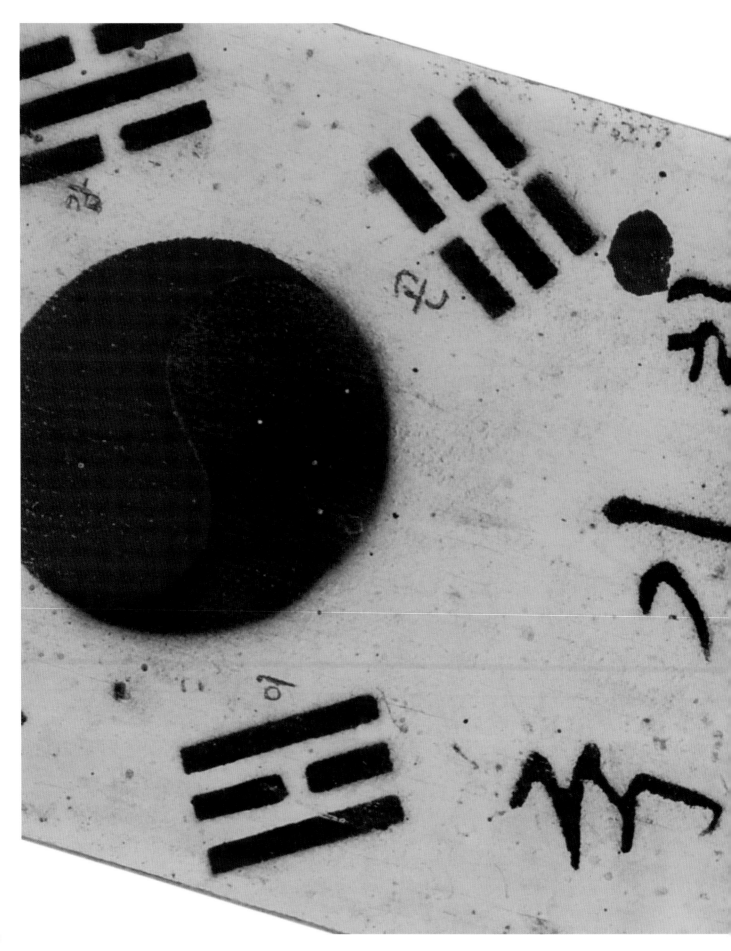

PART I. KOREAN WAR ART IN THE COLLECTION OF CHESTER AND WANDA CHANG

The Smithsonian and the 60th Anniversary of the Armistice: Remembering the Korean War

The Asian Cultural History Program began research on the Chester and Wanda Chang Collection of Art from the Korean War, for which this publication presents a preliminary report, in 2013 as part of the commemorative activities for the 60th anniversary of the Korean Armistice Agreement (July 27, 1953). In beginning the project we noted that, as others have before (NHHC 2014; and cf. Blair 1987; Dowdey et al. 2003; Pash 2012: 30), the Korean War has often been considered the "Forgotten War" in the United States and Canada, as the more pervasive and widely publicized images of the Vietnam War, the Gulf Wars, and World War II have dominated public discourse. However, the utter devastation caused by the Korean War, and the country's subsequent revival, are certainly not forgotten in Korea. Nor has the war ever been forgotten by the veterans who served in the conflict and their families. Scholars have long recognized the war's lasting impact on the history of East Asia, on the worldwide confrontations of the Cold War, and on the economic and political development of the Korean Peninsula and the surrounding region (Heller 1977; Kang 2011; Matray 2011; Wade 1990). In almost every sense it is not and should never be a "forgotten" war.

Yet looking at histories of Korean art, alongside the inspiring Korean artworks produced even during the darkest days of the war, we came to recognize that this entire period of the war had indeed been characterized by the production of what we may call "forgotten art." As artists negotiated their own paths of production through the devastation of the war, many turned to the creation of souvenir crafts in order to support themselves and their families. This substantial body of art and craft work seems to be largely missing from mainstream Korean art history and is underrepresented in museums, including those of Korea. The focus of this collection survey is therefore the "undiscovered" or "missing" story of Korean artists and artisans and their products from the Korean War. This is in stark contrast to the comparatively well-known history of photography and artworks by American and other military artists who depicted wartime subjects, such as those represented within the Korean War component of the art collections of the U.S. Navy (NHHC 2014), Army (Klish 2011), and Air Force (Swan 2011), and also by Korean artists working among the Republic of Korea (ROK) military.[1] Consequently, the authors of this report proposed that, as a 60th anniversary initiative and as the next in a series of publication and research projects from the Korean Heritage Project of the Smithsonian's Asian Cultural History Program, we should undertake the study of the private collection of Dr. and Mrs. Chester and Wanda Chang, as it held much promise as a record of the undiscovered Korean art of the Korean War.

This study builds upon a history of Smithsonian research on Korean cultural history, including the Korean War. For example, prior to joining the Smithsonian as Curator of Asian Ethnology in the National Museum of Natural History's Department of Anthropology in 1959, Eugene I. Knez served from 1949 to 1953 in diplomatic posts in Korea and Japan including as Cultural Affairs Officer and Public Affairs Officer. From 1949 to 1951, Knez

was Chief of Branch Operations for the United States Information Agency, headquartered in Seoul and relocated to Busan at the height of North Korean occupation in 1950. The then-director of Korea's National Museum in Seoul, Kim Chewon, requested Knez's assistance in preserving the museum's treasured collections. Knez responded by arranging to transport the museum's collections and staff by boxcar from Seoul to Busan (See Bain 2002; Knez and Kim 1997), beginning a relationship that continued into his tenure at the Smithsonian. The spirit of this relationship has persisted through the Asian Cultural History Program's Korean Heritage Project, founded with broad public support in 1985 during the later Smithsonian curatorial tenure of Paul Taylor, supporting ongoing research into Korean history and heritage through collections, outreach, and exhibitions.

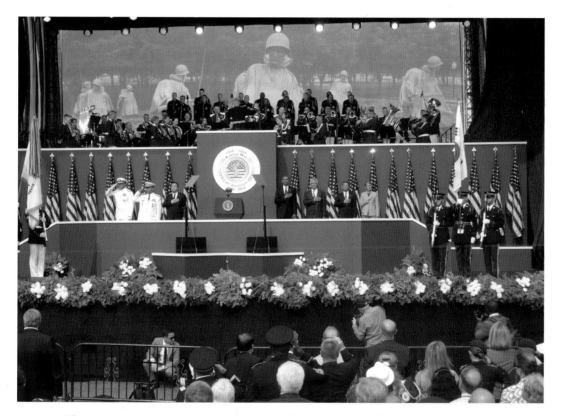

The commemorative ceremony for the 60th anniversary of the armistice ending the Korean War held on July 27, 2013, near the Korean War Veterans Memorial in Washington, D.C. From left to right: James Alexander Winnefeld, Jr., Vice Chairman, U.S. Joint Chiefs of Staff; General Jeong Seung-jo, Chairman of the Joint Chiefs of Staff of the Republic of Korea; Kim Jung-hoon, Special Envoy of the President of the Republic of Korea; Barack Obama, President of the United States; Chuck Hagel, U.S. Secretary of Defense; Eric Ken Shinseki, U.S. Secretary of Veterans Affairs; and Sally Jewell, U.S. Secretary of the Interior. Photo courtesy of the Embassy of the Republic of Korea.

The Smithsonian's Korean Heritage Project and Korean War Art

The research presented in this report was undertaken as a component of the Asian Cultural History Program's Korean Heritage Project. Established and maintained through private donations since 1985, the project supports the acquisition, conservation, restoration, and exhibition of Korean collections and research on Korea's heritage and other Korean cultural activities at the Smithsonian Institution. Among the outcomes of the project is the National Museum of Natural History's Korea Gallery, first opened to the public in 2007 and now seen by millions of visitors each year. Two objects in that exhibition were loaned by Dr. and Mrs. Chang, including a Goryeo Dynasty (918-1392) bronze mirror. A book describing the exhibition (Taylor and Lotis 2008) includes a brief history of the Smithsonian's important collections from Korea, also explored in Chang-su Cho Houchins's history of early United States diplomatic collections (Houchins 2004). In 2011, the Asian Cultural History Program published *Symbols of Identity: Korean Ceramics from the Collection of Chester and Wanda Chang* (Lotis and Lee) under the auspices of the Korean Heritage Project, and thus began intensive study of objects from the Chang Collection. The component of the Chang Collection described by Lotis and Lee consisted of ceramics that had undergone thermoluminescence testing in order to provide approximate dates of manufacture, against which other ceramic works may be compared. This kind of "type collection" of pieces analyzed with this method provided a substantial new source of information on Korean ceramics (Taylor 2011).

As with *Symbols of Identity*, this book stands within a larger series of collection-based studies of Asian heritage published by the Asian Cultural History Program. In the present volume, we considered that the acquisition of Korean War art at known places and times, as remembered by the collector, might similarly provide a potentially useful framework for future comparative study. The present volume's authors have also organized the photographs and information about the Chang Collection, including not only the Korean War artworks featured in this publication but also other potentially related objects, which could form the basis for future study. In this way, our preliminary survey of Korean War art from the Chang Collection presented here fits well within the goals, outcomes, and history of the Smithsonian's Korean Heritage Project.

This introduction to a private collection and its significance should therefore serve as a reference for studies in this subfield of Korean art history and as an impetus for future collection-based research. We suspect that many more Korean artworks of this kind and from this period probably exist within both Korean and overseas collections, but these collections lack exposure and remain understudied partly because artworks of this kind have not been a major focus of museum collecting to date. In addition, certain types of artworks from the Korean War period are particularly difficult to date because their popularity as souvenirs among visiting foreign troops often led to later mass-produced imitations. As the study of this period's art becomes more developed, it may be important to trace the provenance of "souvenir art" that returned to the U.S. and other countries. For example, objects obtained by soldiers who had brief visits to Korea provide an opportunity to determine specific dates and locations for the acquisition of the artifacts. The present

report on the Chang Collection has taken some important initial steps toward this goal by organizing the collector's recollections and information about his own collection in light of the relevant existing literature, and by presenting photographs and descriptions of that portion of the Chang Collection clearly associated with the Korean War. This study, hopefully alongside comparative studies of other collections in the future, will open up the possibility of more determinative comparative and materials science analyses, which may independently confirm the authenticity of and the accuracy of our information about these important artifacts. We hope that one result of this publication will be that Korean War veterans and their families may take part in this ongoing effort by facilitating the study of their own collections along with the associated documentation about where and when objects were obtained. Comparative study across private and museum collections will be of great importance in piecing together the narratives of wartime Korean art and craft.

Recognizing the potential and timeliness of the topic, the Korean Cultural Center of the Embassy of the Republic of Korea, Washington, D.C., generously supported the costs of this Smithsonian initiative which had two main goals: first, to assemble photographs of all the potentially relevant objects and prepare a comprehensive database of the Chang Collection, from which we could identify the portion of materials most likely to be related to the Korean War period; and second, to provide a preliminary description and assessment of the Korean War period objects in this collection. Dr. Chester Chang also supported this initiative by largely funding the cost of photography. The authors would also like to thank Dr. Chang for making the collection available for study on numerous occasions and for providing his memories and knowledge of each object during extensive interviews.

Dr. Chester Chang, Collector

Dr. Chester Chang was born at Jukdong Palace in Seoul, Korea, on February 7, 1939, and given the Korean name Chang Chung-ki (장정기) at birth, using the Korean convention of writing family name first. In 1947, his father became the first Korean consular official in Los Angeles; when in December 1948 Chester and his mother and two brothers arrived there by plane from Korea to join him, the father gave his son Chung-ki the English name "Chester," after the U.S. president Chester A. Arthur. The name was chosen because Min Yong-ik (민영익), the cousin of Chester Chang's great-grandfather Min Yong-whi (민영휘), i.e. Chester's mother's father's father, personally presented his credentials to President Arthur in September 1883 in his capacity as Korea's first ambassador to the United States.

Returning with his family to Korea when his father's diplomatic tour ended in 1953, Chester attended Kyunggi Junior and Senior High School (경기고) from 1953 to 1957. From 1953 to 1955, classes were relocated to Busan due to the devastation of Seoul during the war. He relocated along with the school from Busan back to Seoul in 1955. At Kyunggi, he studied with Park Sang-ok (박상옥), a major figure in the teaching and practice of Korean modern art. Park was also a close family friend, especially of Chester Chang's mother's younger brother Min Byung-son (민병선), who had grown up with Park and had been his classmate

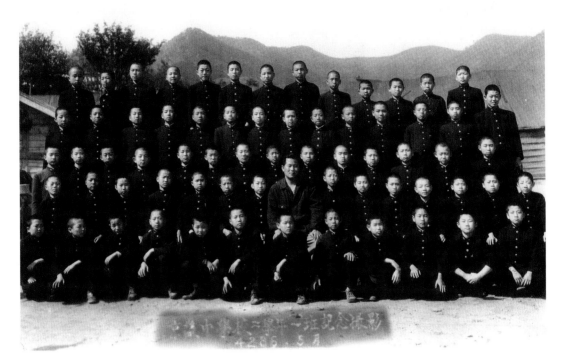

While living in South Korea in the 1950s Chester Chang (far right, second row from the top) attended the prestigious Kyunggi High School. This photograph of the 54th graduating class (graduated in 1957) was taken in the winter of 1953 in Busan. Also pictured is the acclaimed artist Park Sang-ok (박상옥, seated center) who taught the class and inspired Chang's passion for Korean art.

at Kyunggi High School. Park personally introduced Chester Chang to renowned Korean artists and encouraged his appreciation and collecting of art. This influence, along with a long-standing family history of art collecting, has greatly affected Dr. Chang's collection, and he contends that his family's collections are a means by which he can maintain and communicate the history of Korea (Lotis and Lee 2011: 9). Chester Chang particularly credits the advice and collecting expertise of his aunt, Lim Chang-soon (임창순), the wife of Chester's mother's older brother Min Byung-do (민병도), in building his appreciation for Korean and other Asian art. Chester Chang returned to the United States in the summer of 1957, registering immediately at Los Angeles High School where he graduated with his second high school diploma in 1958. He then attended the University of Southern California before earning his Ph.D. in Public Administration from the University of La Verne. He became an airplane pilot, working for private aviation industries from 1962 to 1975. Since 1975, Dr. Chang has been employed as a Federal Aviation Administration (FAA) official, with posts in Tokyo, Seoul, and Saudi Arabia, among other stations, returning to Los Angeles after the end of the Gulf War in 1992 and continuing his work with the FAA based in Los Angeles since that time. He married his wife Wanda at the U.S. Embassy in Seoul on March 21, 1978. Her Korean name was Kim Won-oak (김원옥), but after their marriage a friend at the embassy suggested she take the name Wanda, which later became her legal name in the United States just as Chester Chang's legal name had changed within a year of his own first arrival. By the time of their marriage, Chester Chang's collections and those of

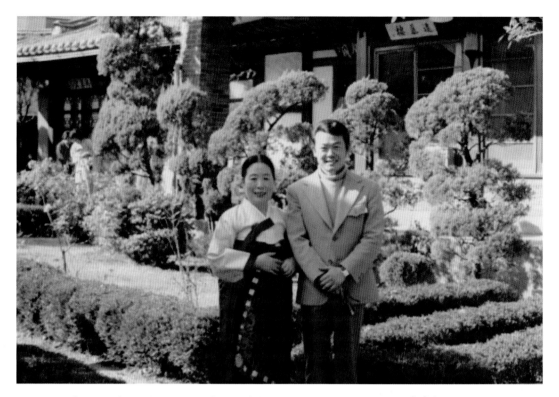

Chester Chang (seen on right) with his aunt, Lim Chang-soon (임창순), who helped him develop both his interest in Korean art and his collection. Several objects in the Chang Collection were gifts from this aunt, the wife of Chester Chang's mother's brother Min Byung-do (민병도).

his family members (including the collections of his mother, which he later inherited) had already been essentially completed. Dr. Chang's career in aviation undoubtedly facilitated his collection of pieces from around the world, mostly prior to the 1980s. The Korean art in the Chang Collection, represented in part by this survey, numbers over one thousand pieces and extends from the earliest periods of Korean history to the modern day (Lotis and Lee 2011: 10). Pieces from the Chang Collection have been exhibited in museums around the world, including the Smithsonian's National Museum of Natural History, the Los Angeles County Museum of Art, and the Korean National Museum (Lotis and Lee 2011: 11; Taylor and Lotis 2008: 72).

Undiscovered Art, a Research Resource for Korea's History

During the deep economic dislocations caused by the war, United Nations personnel and other foreign nationals, through their desire for souvenir art, provided a source of hard currency and other resources for Korean artists. For this reason, we find even well-known and important Korean artists among those who began producing a new type of art for what

we may term an "internal" export market, for sale to foreign troops stationed in Korea. These artists include Lee Jung-seop (이중섭), Park Sookeun (박수근), Hoe Won (회 원), Byeon Kwan-sik (변관식), Ha Eun (하은), Chu Dang (추당), and Song Mi (송미). It was surely difficult during the war to imagine the revival and economic growth that later occurred in South Korea, while North Korea's economy would be left far behind. In fact other wartime artists such as Kim Kwan-ho (김관호), perhaps moved by ideology or by misplaced hope for a better future, decided instead to settle in what is now the Democratic People's Republic of Korea (North Korea).

The role of the ceramic souvenir plate in the wartime economy is particularly noteworthy and has been emphasized in a recent Lotte Gallery exhibition in Seoul, Korea (August 29 – September 24, 2013). This exhibition included a series of ceramic plates produced during the Korean War alongside later ceramics in order to trace the growth of Korean ceramic exports and use ceramics as a measure of the international acceptance of Korean designs, artistry, and craftsmanship.[2] This 2013 exhibition appears to reinterpret art of the Korean War as a formative period within an important transition in Korean art. However, it is not enough to say that the transition should solely be attributed to a new market for Korean goods, though that was certainly part of the dramatic change taking place during the war. Scarcity of materials limited painters' access to canvas or silk necessary to produce paintings in the classical style. Instead, many survived by painting on ceramics that, after being fired, could then be sold for hard currency or traded to foreign nationals for scarce goods. Not only was a new economy created in the independent Republic of Korea out of the terrible paucity of the war, but there also arose a new vibrancy in artworks which were of international appeal yet drew on the most traditional of Korean themes.

It is important to note that Korean artists and artisans producing souvenir art, unlike the official military artists and photographers (mostly from foreign militaries but including some Koreans), rarely depicted scenes from the war itself. Instead, they found inspiration in Korea's past and therefore tended to depict the classical and the traditional, often producing works emulating the so-called "genre" scenes of the Joseon Dynasty (1392-1910). In this sense, the Korean War artworks depicted here are predecessors to *Hallyu*, or the "Korean Wave" of contemporary art in the twentieth and twenty-first centuries, in which artists creating music, film, videogames, animation, and other contemporary art forms draw inspiration from Korea's classical forms even as they become modified for international tastes. The Korean Tourism Association (2005) notes that *Hallyu* refers to the phenomenon of Korean popular culture spreading across the world, particularly in how Korean dramas and films have earned worldwide recognition for their artistic values and for their integration of ancient Korean themes, motifs, and recognizable forms. The significance of *Hallyu* has led the Korean Cultural Service to compile a series of New York Times articles into annual volumes titled *The Korean Wave: As Viewed through the Pages of the New York Times.* However, few have investigated the dire necessity of producing marketable artworks to be "exported" within Korea during the Korean War period as one of the factors influencing Korean artists in their late-twentieth-century adaptations to an international market. We are here presenting examples of Korean artists' works, produced during the Korean War, as being very likely the incunabula of the later Korean wave of influential artistic exports, particularly because the artistic representations produced during this period so strongly emphasized traditional Korean motifs.

The prevalence of idyllic and classical Korean themes within Korean War art reflects the relationship between artists and markets. During this period, artists and artisans adopted new techniques and media to suit emerging customer preferences. For example, though Korea had no historical legacy of painting representational images on plates to be hung decoratively, this Western form was highly suited to the production of souvenir pieces and was adopted by great Korean artists in order to adapt to survive the most difficult times of war. The artists and artisans producing such works seem to have been disinclined to produce art directly depicting the devastation of the war, perhaps preferring to depict related themes in symbolic ways. Consider the glazed ceramic plate bearing the title *Choon-Jo (Early Spring Morning)* by Byeon Kwan-sik (1899-1976) (Cover and p. 27). In the long, cold winter whose end is depicted in this image of seasonal transition, one might find a metaphor for the terrible war from which the people of Korea will emerge. In this evocative piece, a great artist working under austere wartime conditions has captured a timely sentiment of temporary devastation while imbuing the work with echoes of beauty, hope, and resilience.

PART II. CATALOG

LEE JUNG-SEOP 이중섭

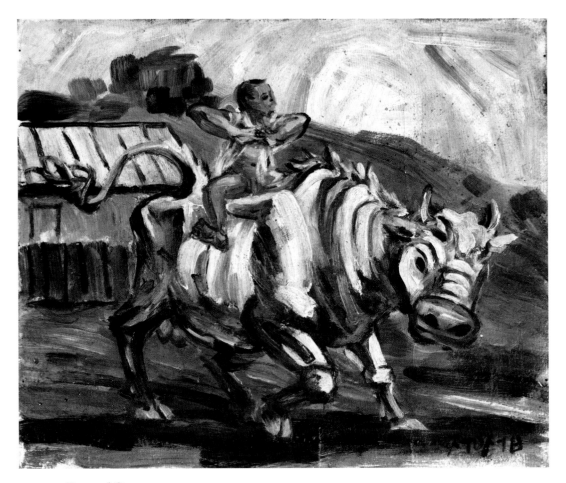

Boy and Ox
Lee Jung-seop (1916-1956)
Ca. 1950
Cardboard and paint
26 x 31 cm

Lee Jung-seop is one of the most renowned Korean artists of the twentieth century and part of the first generation of Korean artists to engage with and explore Western styles of painting. From a young age he was active in the avant-garde art scene in Japan, with several of his early works featured in exhibitions held by the Association of Free Artists. This group of Japanese and Korean artists formed in 1937 with the intent to derive uniquely Asian idioms from the more geometrically abstract styles popular in Europe at the time.[3] The examples of Lee's work published here are typical of his form and content. The characteristic thick brushstrokes and warped figurative imagery depict the familiar images of oxen and climbing children for which he is known. Impoverished most of his life, Lee would paint on any available media, frequently using scrap material such as cardboard and cigarette packaging. According to the collector, the painting "Boy and Ox" is likely painted with industrial paint, possibly from a United States military surplus, on a piece of cardboard.[4]

Climbing Children
Lee Jung-seop (1916-1956)
Ca. 1950s
Glazed ceramic tile
15 x 20 cm

Lee Jung-seop was separated from his family in 1952 when he sent his wife and children to live with his wife's parents in Japan.[5] This separation during the Korean War is believed to have strongly influenced the subject matter of his paintings in this period. As Kim Youngna, Director of the National Museum of Korea, explains, "[Lee] drew bulls in violent brushwork and painted idealized images of his family in paradise as if attempting to resolve his isolation and despair."[6] His works depicting climbing children are believed to be inspired by thoughts of his sons and have been compared to motifs of children climbing grapevines commonly found on Goryeo Dynasty (918-1392) porcelain.[7] Though it is common for his works to feature nude figures, it appears as if the image on this tile has been altered to remove any nudity. Perhaps this ceramic tile was tampered with at some point by someone wishing to censor Lee, which might also explain why the artist's signature has also been removed from the piece. The collector believes this ceramic tile was produced during the war period at the same kiln in Busan as many other ceramics in this publication.

KIM KWAN-HO 김관호

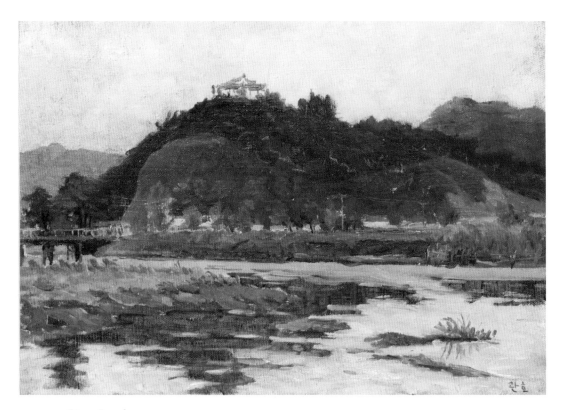

River Landscape
Kim Kwan-ho (1890-1959)
Ca. Late 1950s
Oil on canvas
23.1 x 31.4 cm

Along with Ko Hui-Dong (고희동) (1889-1965), Kim Kwan-ho is known for being one of the first Koreans to paint in a Western-influenced style. Since the nineteenth century, the Meiji government of Japan had actively promoted Western art forms, a cultural shift that diffused to Korea when Korean artists began studying in Tokyo in the early twentieth century.[8] Shortly after the Japanese annexation of Korea, Kim Kwan-ho travelled to Japan to study Western style painting at the Tokyo School of Fine Arts with the support of a scholarship from the Korean Governor-General.[9] In 1916, he was the first Korean to exhibit at the prestigious *Bunten* national art exhibition in Tokyo sponsored by the Japanese government.[10] His painting "Sunset," featuring two nude females along the Daedonggang in Pyeongyang, was awarded a prize at the exhibition. However, the work was viewed as obscene and withheld from Korean newspapers, creating some notoriety for the artist.[11] The details of Kim's life become less clear towards the middle of the century, though it is believed he worked primarily in Pyeongyang for the rest of his life, ultimately serving as the director of the North Korean National Museum.[12] His painting "Daughter at Wedding" is dated to 1957, two years before the artist's death, suggesting he enjoyed an active career late into his life. The stoic expression of the bride, adorned with a bridal crown, or *hwa gwan* (화관), expresses the complex emotions experienced on her momentous day. Along with "River Landscape," which Chester Chang believes to also have been painted in the late 1950s, these two paintings provide a glimpse into the oeuvre of a seminal artist in the history of Korean modern art.

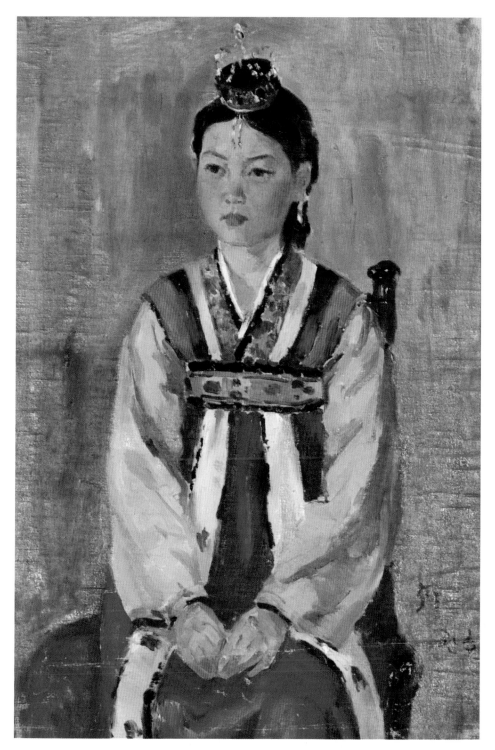

Daughter at Wedding
Kim Kwan-ho (1890-1959)
1957
Oil on canvas
52.7 x 34.4 cm

PARK SOOKEUN 박수근

Three Women and Child
Park Sookeun (1914-1965)
Ca. Late 1950s
Oil on canvas
30.48 x 40.64 cm

Park Sookeun has become one of the most cherished Korean artists in recent decades in part for his ability to capture the beauty of pastoral life, as exemplified in his work "Three Women and Child." It is believed that he was heavily influenced as a child by the art of French realist Jean-François Millet,[13] resulting in his tendency to paint everyday rural scenes. Impoverished throughout his life and self-taught as an artist, Park expressed his personal connection to his subjects through the serene manner in which they are depicted. The soft browns and grays, combined with an unrefined granite texture, give many of his paintings an earthy and monumental appearance, as if carved from stone. These qualities earned Park posthumous recognition in Korea as one of the country's premier artists of the twentieth century.

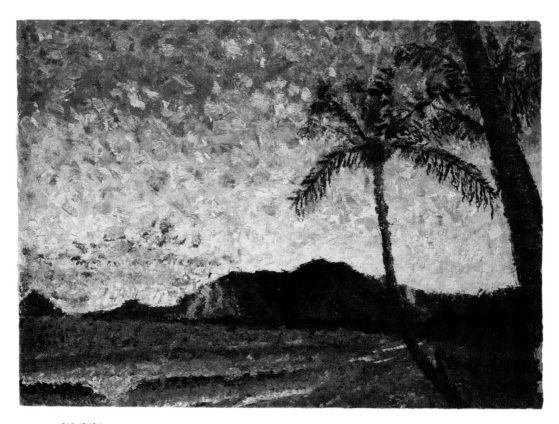

Waikiki
Park Sookeun (1914-1965)
Ca. early 1960s
Artist board, oil paint
20.6 x 30.5 cm

Never a commercially successful artist in his lifetime, Park and his family survived in large part through the support of American diplomats and servicemen who commissioned portraits from the artist and supplied him with painting materials throughout his career. During the war, Park moved from Pyeongyang to Seoul and found employment painting portraits for American servicemen.[14] Similarly, the painting "Waikiki" was commissioned by an American engineer who was working in Korea in the 1960s to establish the American Forces Korean Network (AFKN) radio station. Park was at first unable to imagine the palm trees and beaches from the engineer's descriptions, until he provided Park with a photograph of Waikiki from which this painting was created.[15] This history explains why the subject matter of this painting diverges so dramatically from the rural scenes for which Park is known. Chester Chang acquired both "Waikiki" and "Three Women and Child" from the engineer when he was working as a pilot examiner based in Tokyo in the early 1970s.

HOE WON 회 원

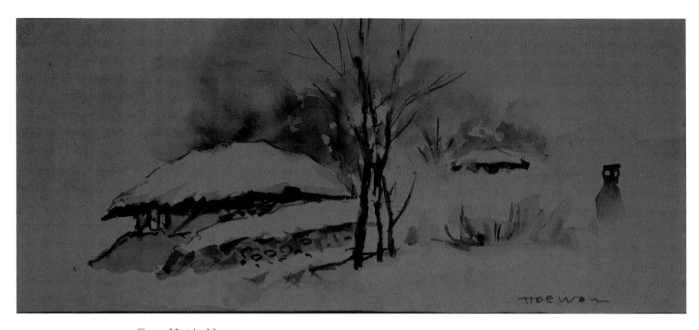

Grass Hut in Nature
Hoe Won
Ca. 1950s
Watercolor painting
16.1 x 38 cm

While there is very little biographical information available about the artist who signed his paintings "Hoe Won," the artist consistently signed his works in Latin script, indicating that he was an artist who primarily painted works for foreign buyers. The presence of the United States military in South Korea to this day makes it likely that many of these collectors were in the military or are the family of servicemen. In this way, Hoe Won could be another artist responding to the influx of foreigners brought by the war. His subject is typically a pastoral scene of an individual or a couple of people isolated in nature, while his style is muted and minimalistic, utilizing negative space within the image to great effect. The resulting image is both visually appealing and distinctly Korean, a work of art that would easily appeal to visitors wishing to take a part of their Korean experience home with them.

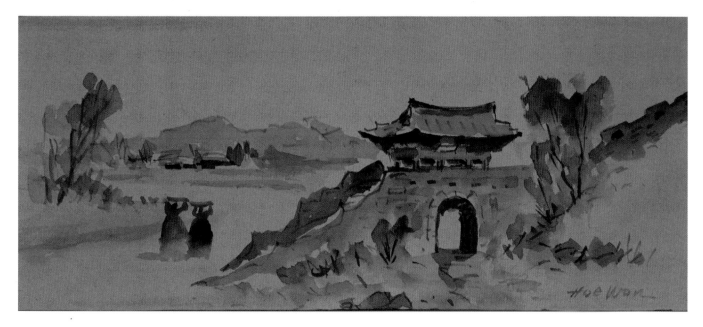

Gate over Creek at City Wall
Hoe Won
Ca. 1950s
Watercolor painting
16.1 x 38 cm

BYEON KWAN-SIK 변관식

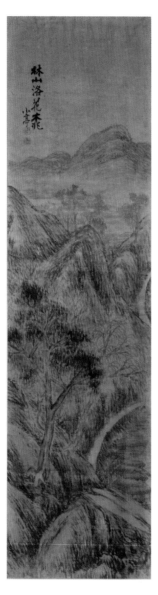

Peach Blossoms Falling in a Mountain Grove
(*Im san nak hwa mok jo*) 林山洛花木兆
Byeon Kwan-sik (1899-1976)
Ca. 1950s
Silk and paint
124.1 x 31.7 cm

Byeon Kwan-sik was imbued from an early age with lessons from the traditional Korean school of painting by his grandfather Cho Seok-jin,[16] a master painter in the late Joseon Dynasty (1392-1910). As other Korean artists were drawn towards Western-style painting in the early twentieth century, Byeon continued to predominately paint landscapes in the traditional style, albeit with a proclivity to experiment with modern techniques and themes within this framework. "Peach Blossoms Falling in a Mountain Grove," one of the seven Byeon Kwan-sik landscape scrolls from the Chester Chang Collection, is typical of the artist. Recognized as a master of landscapes, Byeon utilizes a variety of brush stroke techniques to achieve a realistic and dynamic portrayal of nature. Throughout his career he emphasized Korean traditions and rejected Chinese and Japanese artistic influences in order to foster a uniquely Korean artistic identity. At the same time, like much of Byeon Kwan-sik's work this scroll experiments with tradition in its use of rough brushwork, a technique that invokes the power of nature and the vitality of the landscape.[17]

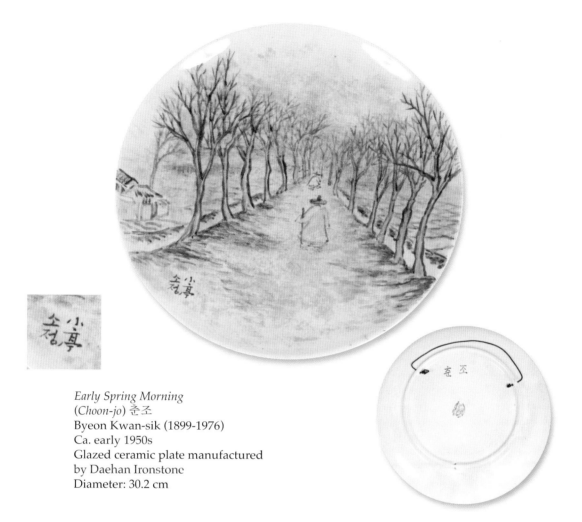

Early Spring Morning
(*Choon-jo*) 춘조
Byeon Kwan-sik (1899-1976)
Ca. early 1950s
Glazed ceramic plate manufactured
by Daehan Ironstone
Diameter: 30.2 cm

Although famous for his landscape scrolls, this plate by Byeon Kwan-sik was produced while working at the Busan kiln, where he was taking refuge during the siege of Busan. Byeon was one of the most iconic Korean painters to decorate plates at the kiln with several of his ceramic works from this period featuring his distinctive style. This plate from the Chang Collection features a pair of elderly men wandering down a country lane, a common motif in Byeon's paintings that emphasizes the relationship between humans and their environment.[18] Considering this motif and the period the plate was produced, the barren landscape on this plate may be interpreted as reflecting the artist's sentiments during the war. Furthermore, while the plate is signed with Byeon Kwan-sik's artist's name "So jeong" in hanja characters "小亭", as is typical, Byeon has also signed his name in Hangeul script "소정." This is noteworthy because Byeon predominately signed his work exclusively in hanja characters, with other notable exceptions being three known ceramic plates produced in the same period as this plate.[19] If the Korean War affected this stylistic decision with regards to Byeon's ceramics, they may reveal the essence of the community at the Busan kiln and the influence it had on the future of Korean art.

CHU DANG 추당

The following works are attributed to the artist Chu Dang, identified by the artist's signature and *nakgwan* (낙관), or red artist's seal, found in either hanja characters or Hangeul script. Although little is known about the artist's biography, these plates suggest that he produced plates at the Busan kiln during and after the Korean War. Like many creators of Korean art and souvenir objects geared toward foreign markets, Chu Dang seems to have embraced the themes of Joseon Dynasty (1392-1910) genre paintings in his depictions of everyday ceremonies, tales, music, and games in both ceramic arts and the accompanying scroll painting, "Parents Welcome Auspicious Ceremony" (*"Chin yeong ka ui"* 親迎嘉儀)."

Parents Welcome Auspicious Ceremony
(*Chin yeong ka ui*) 親迎嘉儀
Chu Dang
Ca. 1950s
Scroll Painting
108.2 x 32.6 cm

The fluid brush strokes and vibrant colors characteristic of Chu Dang's style are evident in this scroll, the preferred surface medium of traditional Korean painters. This typical scene depicts the procession of the bridegroom's party, signified by the red and blue *cheongsachorong* (청사초롱) lanterns that would be used to light the path of the procession to the bride's house. Upon reaching the house, the *mokan* (목안), or wooden geese, carried by the man in the red *gat* (갓) headdress, would be presented to the bridal party, symbolizing the union of the couple. The scroll is signed and titled in hanja characters in the top left corner.

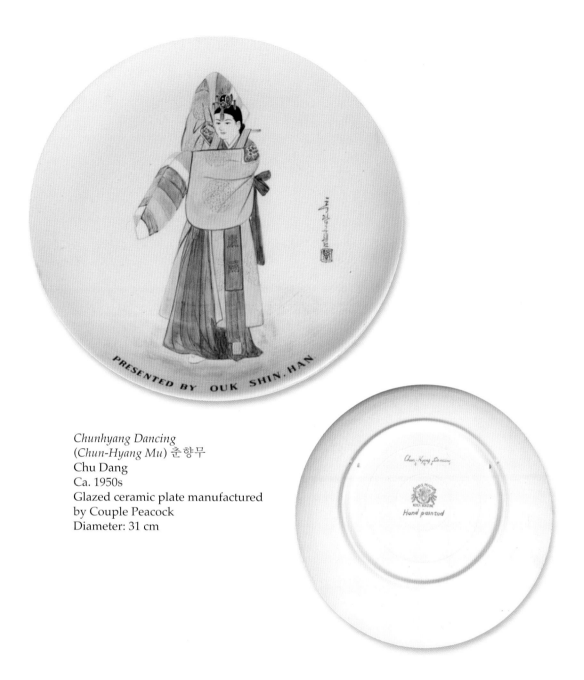

Chunhyang Dancing
(*Chun-Hyang Mu*) 춘향무
Chu Dang
Ca. 1950s
Glazed ceramic plate manufactured
by Couple Peacock
Diameter: 31 cm

This plate depicts Chunhyang, a character from the famous Korean love story, *Chunhyangjeon* (춘향전), dancing in courtly attire. Made popular through *pansori* (판소리) performances, a mode of musical storytelling in Korea, this tale of a young couple's separation and reconciliation remains a favorite folk tale. The obverse of the plate is inscribed "Presented by Ouk Shin. Han," suggesting that this plate was a gift to an American working with the Korean police force during the war, as Ouk Shin Han was a high-ranking law enforcement official at the time. The plate bears the hand-painted *nakgwan* of Chu Dang in hanja characters.

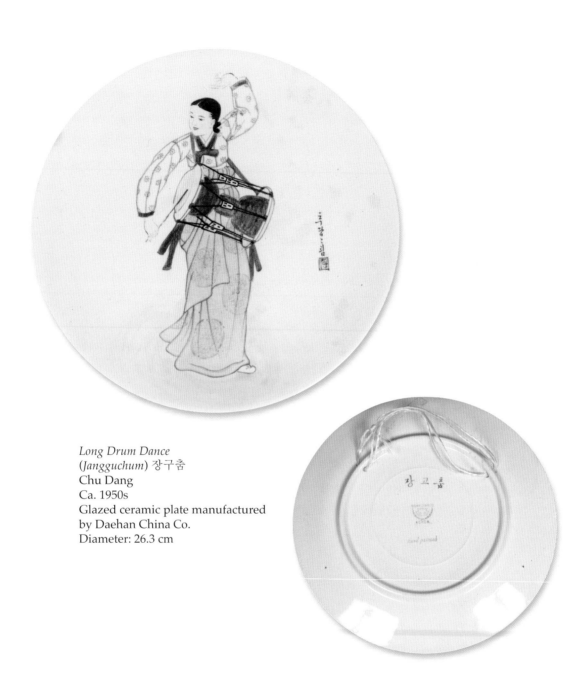

Long Drum Dance
(*Jangguchum*) 장구춤
Chu Dang
Ca. 1950s
Glazed ceramic plate manufactured
by Daehan China Co.
Diameter: 26.3 cm

This plate illustrates a woman dancing and playing the *janggu* (장구), an hourglass drum with two differently tuned heads commonly found in Korean traditional music. Unlike Chu Dang's other works represented in the Chang Collection, this piece bears a hand-painted *nakgwan* in Hangeul script. The reverse features the name of the work in Hangeul as well as a trademark.

Four Girls Playing *Yunnori*
Chu Dang
Ca. 1966
Glazed ceramic plate
Diameter: 31.6 cm

Images of traditional games figure prominently in the depictions of everyday Korean life found on the plates in this publication. These games are often tied to the celebrations and ceremonies unique to East Asia, appealing to foreign customers looking for souvenirs to remember their experience in a new place and culture. The activity pictured here, *yunnori* (윷놀이), is a game of chance frequently played during celebrations of the Korean New Year.

HA EUN 하은

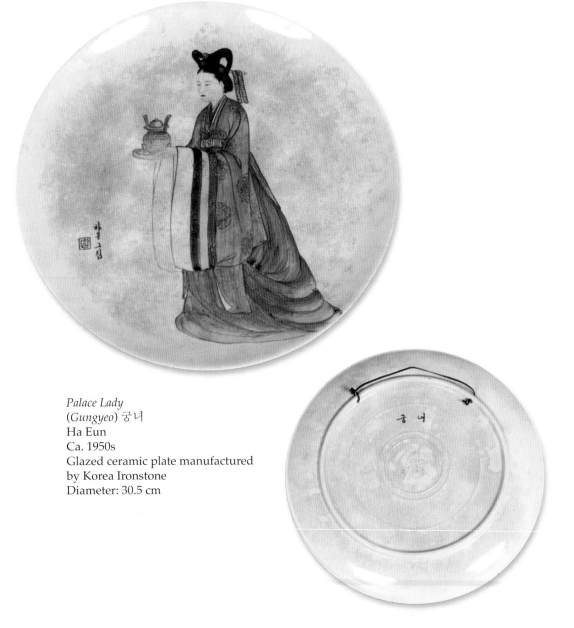

Palace Lady
(*Gungyeo*) 궁녀
Ha Eun
Ca. 1950s
Glazed ceramic plate manufactured
by Korea Ironstone
Diameter: 30.5 cm

The richness of Korean traditions shines through scenes of courtly life, making them popular sources of inspiration for the artists designing souvenir plates at the Busan kiln. Depicted here in ceremonial attire known as *wonsam* (원삼), which was reserved for queens, princesses, and ladies of the palace, the woman is instantly recognizable as elite. Furthermore, the artist Ha Eun has signed not only his signature on the front of the plate, but "궁녀" ("*Gungyeo*") meaning "palace lady" on the back, offering a title for the plate and emphasizing its quality as a work of art.

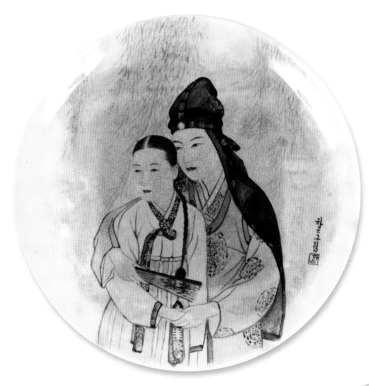

Chunhyang and Gentleman Lee
(*Lee doryeong gwa Chunhyang*) 이도령과 춘향
Ha Eun
Ca. 1950s
Glazed ceramic plate manufactured
by Korea Ironstone
Diameter: 30.5 cm

In the second Ha Eun plate from Chester Chang's collection, the artist has once again titled his piece on the back by hand, inscribing "이도령과 춘향" ("*Lee doryeong gwa Chunhyang*"), which translates to "Chunhyang and Gentleman Lee." This is the second plate from the Busan kiln in the Chang Collection to feature imagery from the famous Korean *pansori*, *Chunhyangga* (춘향가), which relates the love story of Chunhyang and Gentleman Lee.

SONG MI 송미

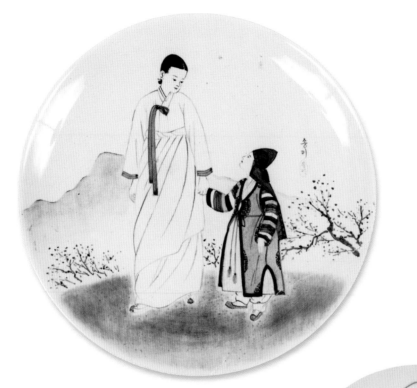

Spring Outing
(*Bomnadeuli*) 봄나드리
Song Mi
Ca. 1950s
Glazed ceramic plate manufactured
by Korea Ironstone
Diameter: 30.2 cm

The tranquil scene of a mother walking with her child in this design by the artist Song Mi invokes the pastoral serenity that is found throughout many of the plate designs manufactured at the Busan kiln. The undertones of nurturance and care conveyed by this scene, coupled with the pair's traditional attire, create a sense of timelessness and permanence. The artist has inscribed a title on the back of the plate "봄나드리" ("*Bomnadeuli*"), or "Spring Outing," emphasizing the perennial quality of family and tradition.

CHIN HEUNG SOUVENIR PLATES

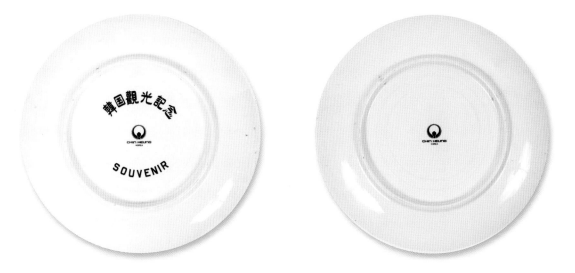

The plates by Byeon Kwan-sik, Chu Dang, Ha Eun, and Song Mi are representative of decorative plates produced at the kiln in Busan in the early 1950s. Chester Chang vividly recalls visiting this kiln as a teenager with his teacher, the artist Park Sang-ok, when he was living in Busan shortly after the war. Park, a central figure in the artist community in Busan at the time, knew many of the artists who had taken refuge at the kiln during the war. While the plates featured previously are individually hand-painted and signed by specific artists, the high demand for souvenir items at the time encouraged some ceramic companies to utilize mass-production techniques to satisfy the market's demand. These techniques, which gave companies the ability to transfer images or designs directly to plates, would have greatly increased the rate of production while diminishing the role of the artist in the production process. Several plates from Chester Chang's collection bearing a "Chin Heung" trademark appear to have been mass-produced in some way, considering the lack of personal touches such as artist signatures and titles that are found on other plates. Furthermore, some of these plates are clearly identified on the back as "Souvenir" in English and "Commemorative Korean Souvenir" (韓国観光記念 or *"Hanguk Gwangwang Ginyeom"*) in hanja characters, encouraging the interpretation that they were produced in large quantity. However, little is known definitively about these Chin Heung objects. Assuming they were mass-produced rather than painted by hand, it is interesting to note the similarity in design compared to the plates featured before. For example, the design of the plate "Four Girls Playing *Yunnori*" produced by Chin Heung (p. 36) is almost identical to the design painted by Chu Dang (p. 31). Like the hand-painted plates, the designs on the Chin Heung plates are clearly derived from traditional Korean genre painting themes, such as scenes from holiday celebrations and courtly life. This suggests that the Chin Heung company was associated with the kiln in Busan and that some of the artists featured for their hand-painted work, such as Chu Dang, may have contributed designs for their productions.

Woman by Tree
Ca. 1950s to 1960s
Glazed ceramic plate manufactured
by Chin Heung
Diameter: 31.4 cm

Boys Flying Kites
Ca. 1950s to 1960s
Glazed ceramic plate manufactured
by Chin Heung
Diameter: 31.6 cm

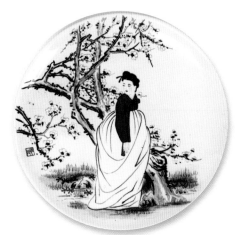

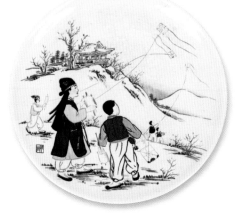

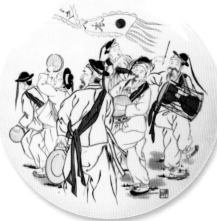

Harvest Dance
Ca. 1950s to 1960s
Glazed ceramic plate manufactured
by Chin Heung
Diameter: 31 cm

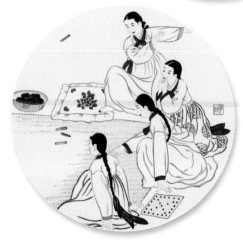

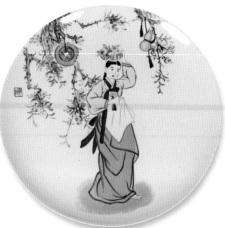

Four Girls Playing *Yunnori*
Ca. 1950s to 1960s
Glazed ceramic plate manufactured
by Chin Heung
Diameter: 31.6 cm

Woman with Pomegranates
Ca. 1950s to 1960s
Glazed ceramic plate manufactured
by Chin Heung
Diameter: 31.2 cm

Fisherman on a Boat
Ca. 1950s to 1960s
Glazed ceramic plate manufactured
by Chin Heung
Diameter: 31.4 cm

Four Men Playing *Baduk*, One Man Smoking
Ca. 1950s to 1960s
Glazed ceramic plate manufactured
by Chin Heung
Diameter: 31.5 cm

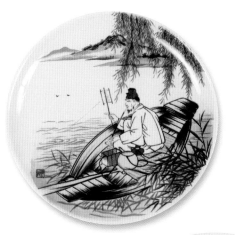

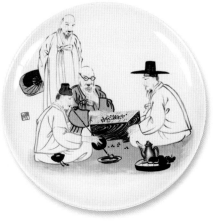

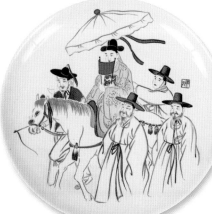

Procession following Official
Appointment
Ca. 1950s to 1960s
Glazed ceramic plate manufactured
by Chin Heung
Diameter: 31.2 cm

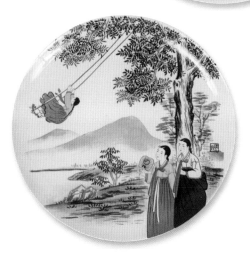

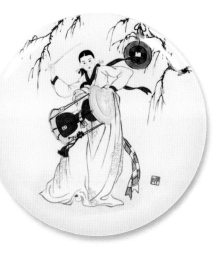

Girl on Swing, Two Girls Watching
Ca. 1950s to 1960s
Glazed ceramic plate manufactured
by Chin Heung
Diameter: 30.7 cm

Janggu Dance
Ca. 1950s to 1960s
Glazed ceramic plate manufactured
by Chin Heung
Diameter: 31 cm

METALWORKS

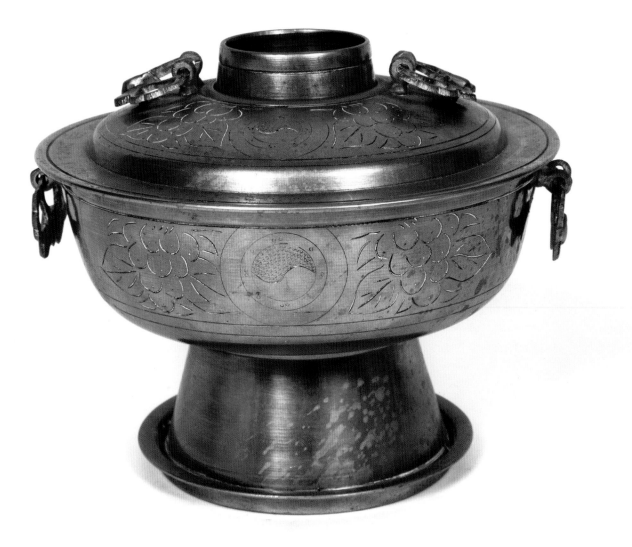

Sinseollo inscribed to Col. Byron W. Ladd from
Gen. Chung Il-kwon
Artisan unknown
Ca. 1950-1953
Brass
17.8 x 17.8 x 15.9 cm

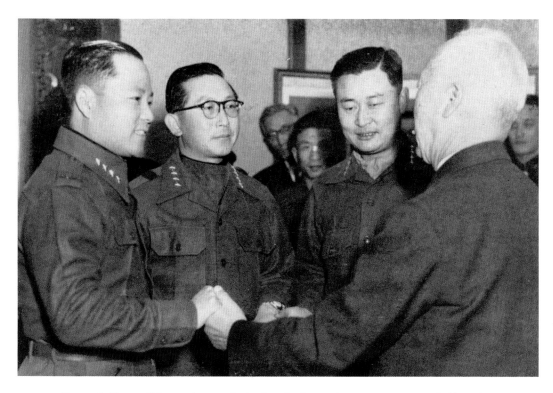

General Chung Il-kwon (center facing) with General Lee Hyung-geun (left) and General Paik Sun-yup (right) as they were made full generals by President Rhee Syng-man (far right), from *Pictorial Korea 1955*, p. 22

Both before and during the war, elaborate pieces of metalwork were often given as gifts to foreigners as tokens of appreciation for their support. A few of these objects are currently preserved in Chester Chang's collection and are displayed in this publication as a testament to this tradition. The *sinseollo*, commonly known in Korea for its use in preparing a food dish by the same name, was also popular as a gift in the war period. This brass *sinseollo* is inscribed "To: Col. Byron W. Ladd / From Gen. Chung Il-kwon," making this vessel a very presitigous gift considering General Chung Il-kwon's role as leader of the South Korean Army for most of the Korean War.

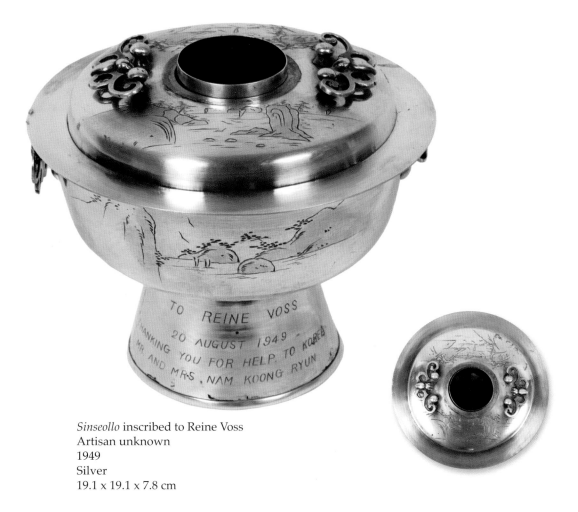

Sinseollo inscribed to Reine Voss
Artisan unknown
1949
Silver
19.1 x 19.1 x 7.8 cm

This silver *sinseollo* is inscribed "To Reine Voss/ 20 August 1949/ Thanking you for help to Korea/ Mr. and Mrs. Nam Koong Ryun." Namgung Ryun (revised Romanization)[20] was the first Korean ship owner after Japanese occupation[21] and eventually became the president of the Korea Shipping Corporation during and after the war.[22] Judging by the date inscribed, this *sinseollo* was likely gifted just before the start of the war in 1950. Though the identity of Reine Voss is not certain, given Namgung's merchant background, it is probable that Voss was a Western business partner of Namgung's during the interwar period.

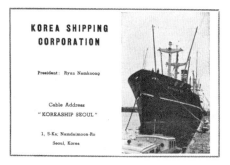

An advertisement from *Pictorial Korea 1955*, published by the International Publicity League of Korea, indicating that the president of the Korea Shipping Corporation was Namgung Ryun.

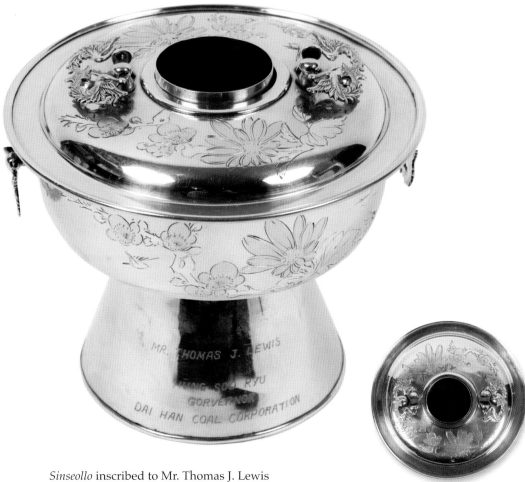

Sinseollo inscribed to Mr. Thomas J. Lewis
Artisan unknown
Ca. 1950s
Silver
14.7 x 14.7 x 9.5 cm

One major concern during the war was the availability of affordable energy sources to heat homes and prepare food during the harsh winters in Korea. In response to this need, the Dai Han Coal Corporation[23] developed a type of coal briquette known as *yeontan* (연탄) which could be acquired cheaply and could be used for both heating homes and cooking meals. The innovative perforated design of the *yeontan* coal briquette allowed for more efficient and affordable heating, providing relief for the civilian population in the Republic of Korea at the time. According to the collector, it is possible that this pure silver *sinseollo* was gifted to Thomas J. Lewis by the Dai Han Coal Corporation during the war period, considering the many close relationships between government corporations and American advisors at this time.

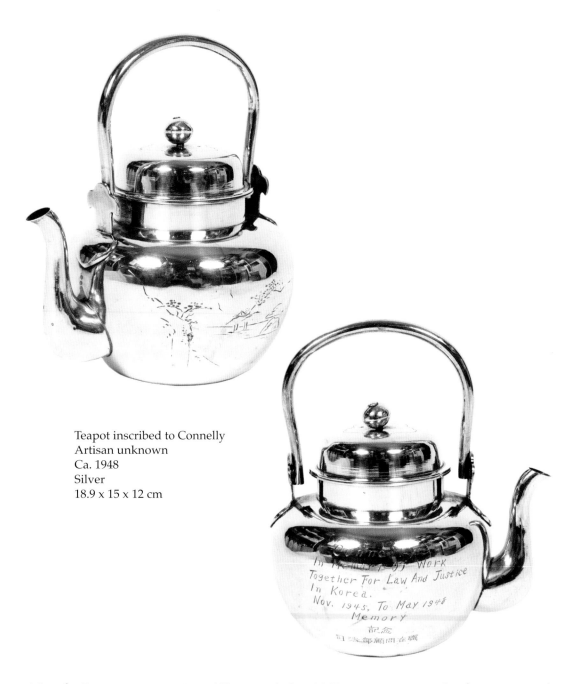

Teapot inscribed to Connelly
Artisan unknown
Ca. 1948
Silver
18.9 x 15 x 12 cm

After the Japanese occupation of Korea ended in 1945 it was necessary for the provisional government of Korea to develop a justice system and a government bureaucracy to maintain law and order in the country. Presumably the Connelly to whom this silver teapot was intended was an advisor assisting with the development of a new justice system in Korea as the piece bears an inscription in English that reads "Connelly/ In Memory Of Work/ Together for Law And Justice/ In Korea./ Nov. 1945, To May 1948/ Memory." Further emphasizing this work as a gift from a government official, below the English inscription the hanja characters reads "Ki Nyum/ Sa Bup Bu Ko Moon Jae Jeek," ("記念/司法 部 顧問在職") loosely translated to "In commemoration/ Current Advisor of Department of Law and Justice."

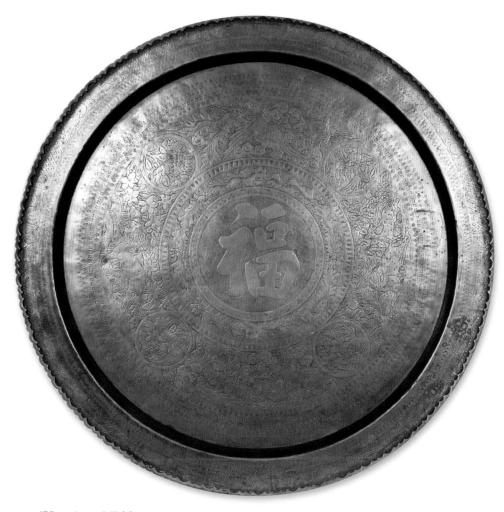

"Happiness" Table
Artisan unknown
Ca. 1950s
Brass
Diameter: 90.2 cm

Following World War II, much of the available brass in Korea had been confiscated by occupying Japanese forces to support the Japanese war effort.[24] During the Korean War, however, the availability of brass skyrocketed as the heavy use of military munitions scattered the cities and countrysides with expended bomb shells and bullet casings. Therefore, it can be presumed that many brass objects cast during or after the war, such as this large plate, were made from repurposed brass munitions. The pattern on this plate features an ornate floral pattern with the hanja characters "福" ("*bok*"), or "happiness," chased in the center.

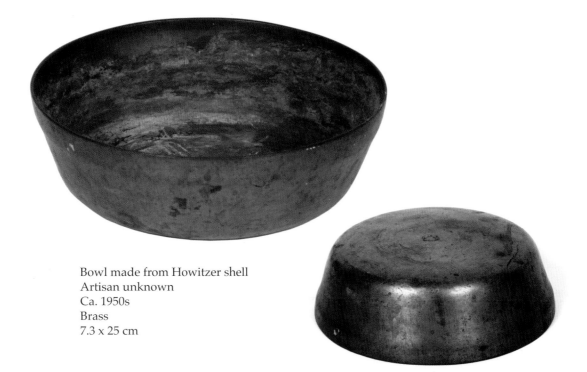

Bowl made from Howitzer shell
Artisan unknown
Ca. 1950s
Brass
7.3 x 25 cm

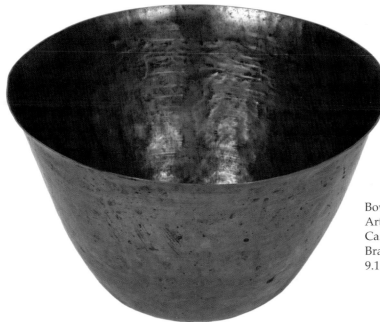

Bowl made from Howitzer shell
Artisan unknown
Ca. 1950s
Brass
9.1 x 22.3 cm

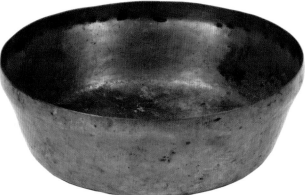

Bowl made from Howitzer shell
Artisan unknown
Ca. 1950s
Brass
7.2 x 26.2 cm

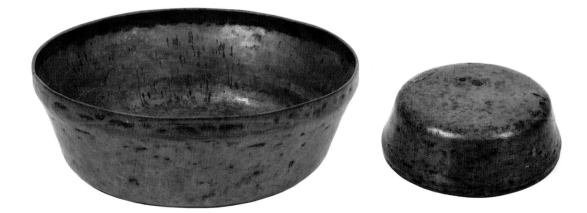

Bowl made from Howitzer shell
Artisan unknown
Ca. 1950s
Brass
7.1 x 24.5 cm

Heavy artillery shelling for periods of the war resulted in a surplus of large brass canisters from discharged Howitzer munitions. Many of these canisters were innovatively repurposed and hammered or cast into bowls of various shapes and sizes. They are extremely durable and could be made useful for a variety of domestic purposes.

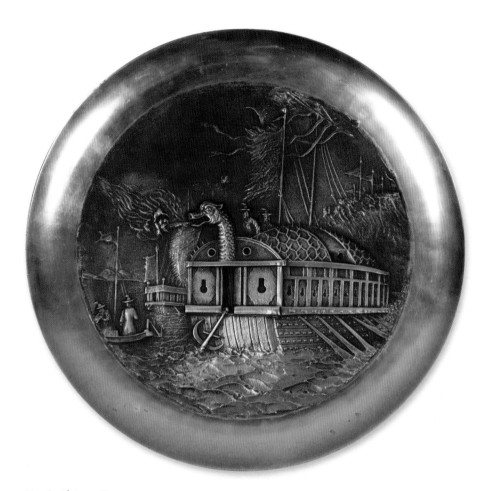

Turtle Ship at Sea
Artisan unknown
Ca. 1950s
Brass
Diameter: 34.3 cm

The design of this plate, likely cast from expended brass military munitions, is that of a *geobukseon* (거북선), or turtle ship. The name was inspired by the shell-like covering that concealed the top deck of the ship, protecting the crew from enemy fire. Though it is believed similar designs may have existed prior to the sixteenth century, the design of the turtle ship is credited to the famous Admiral Yi Sun-Sin. By strategically employing turtle ships in his fleet, Yi Sun-Sin withstood the Japanese during their invasion of Korea (1592-1598), despite being significantly outnumbered by the Japanese fleet. Admiral Yi and his turtle ship are symbols of victory honored to this day in Korea.

WOODWORK

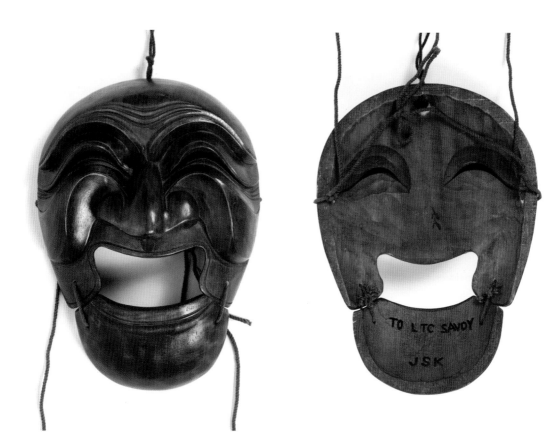

Mask inscribed to LTC Savoy
Artisan unknown
Ca. 1950s
Alder wood
27 x 20 cm

Masks have been used for centuries in Korea in many social contexts. They were worn by soliders in battle, by shamans conducting exorcism rites, and by performers during ritual dances and plays. The Korean mask dance dramas from the Joseon Dynasty (1392-1910), which often employed satire to ridicule the upper classes, have long persisted in distinct regional forms. Today these dramas are preserved as National Treasures and Important Intangible Cultural Properties of Korea. The mask featured here represents a nobleman, or *yangban* (양반), from the *Hahoe byeolsingut talnori* (하회별신굿탈놀이), a famous ritual mask dance drama dated to the twelfth century from the town of Hahoe in North Gyeongsang Province.[25] The aesthetic of the mask is intended to satirize the nobleman, as the wide grin and lidded eyes convey an oafish and ridiculous personality. The set of masks associated with the *Hahoe byeolsingut talnori* (하회별신굿탈놀이) were designated by the Cultural Heritage Administration of Republic of Korea in 1964 as National Treasure No. 121. However, prior to that designation, replicas were made for years as popular tourist souvenirs because the masks represented a unique aspect of Korean culture. According to Chester Chang, this mask was gifted to a Lieutenant Colonel Savoy by the Joint Security Forces of Korea as it is inscribed "LTC SAVOY/JSK" on the back of the chinpiece.

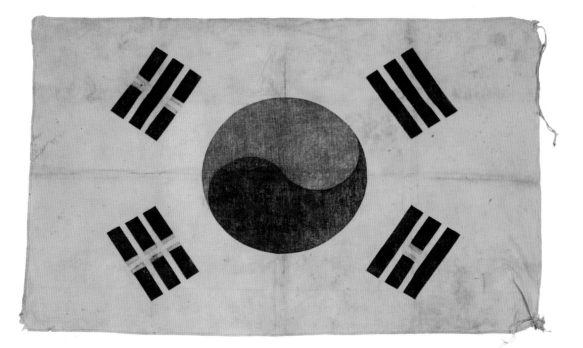

Flag Case with Korean Flag
(*Gukgiham*) 국기함
Artisan unknown
Ca. 1950s
Plywood, paint, cloth
25.2 x 16.2 x 4.1 cm

The flag box shown here dated to the war period would have been a typical object for both local Koreans and foreigners to possess. Before the division of Korea in 1945, the flag informally stood for all of Korea, but was only offically adopted as the national flag of the Republic of Korea in 1949. The flag design is composed of a white ground color symbolizing peace and purity, a red and blue *Taegeuk* (태극) representing the balance and harmony of the universe, and four black trigrams, known as *gwae* (괘), that represent the four elements: sky, water, earth, and fire.

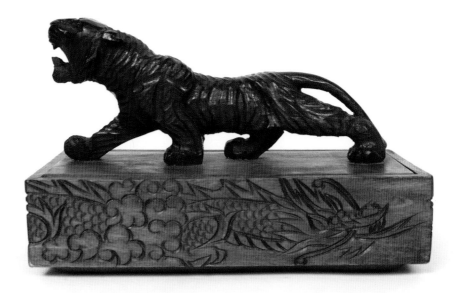

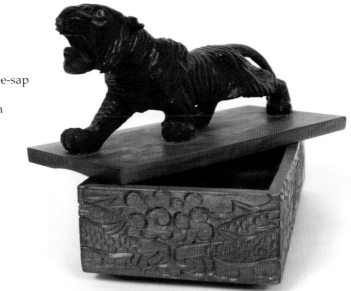

Tiger Box
Artisan unknown
Ca. 1950s
Wood, glue, and tree-sap
based lacquer
20.4 x 12.4 x 10.1 cm

The tiger is regarded in Korea as a guardian that protects one from evil spirits and appears often in Korean folklore from the Joseon Dynasty (1392-1910). The side of the box is carved with the image of a dragon, which in Korean mythology is believed to watch over mines and hoards of gems.[26] These symbols suggest this piece was intended as a box for valuable items. Chester Chang believes this piece was made during the war period and was likely sold alongside other tourist-oriented craftwork.

WOODEN AND CERAMIC FIGURINES

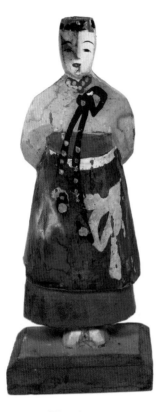

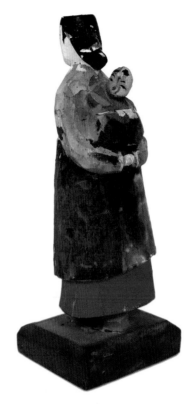

Figurine
Artisan unknown
Ca. 1950s
Wood and paint
12.9 x 5.1 x 3.8 cm

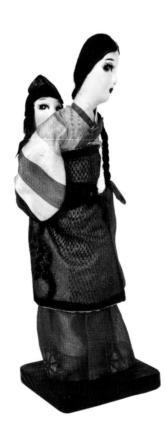

Figurine
Artisan unknown
Ca. 1950s
Cloth and wood
23.8 x 7.8 x 7.4 cm

One effect of the Korean War was the sudden influx of foreign customers into local markets in the form of American and U.N. soldiers. Many of these soldiers wanted to return with souvenirs from their tour of duty to share Korean culture with their friends and family back home. In response to this demand, a market for inexpensive art and souvenirs emerged. Figurines such as the wooden works featured here would have been ideal mementos as they were affordable, durable, and easy to carry. An image in *Pictorial Korea 1955*, one of the earliest English language publications produced in Korea, features an image of a vendor stall filled to the roof with figurines of this type, indicating the proliferation of these works at the time. It is reasonable to presume that thousands of figurines like these, inspired by various archetypes within the Korean cultural milieu, made their way to the United States as either gifts or souvenirs, bringing along a window into traditional Korean life. On the bottom of one figurine there is a personal inscription, "John A. Ebeling/Aug. 7, 1953/ 1953/Pusan, Korea," emphasizing that these figurines were primarily collected as personal memorabilia.

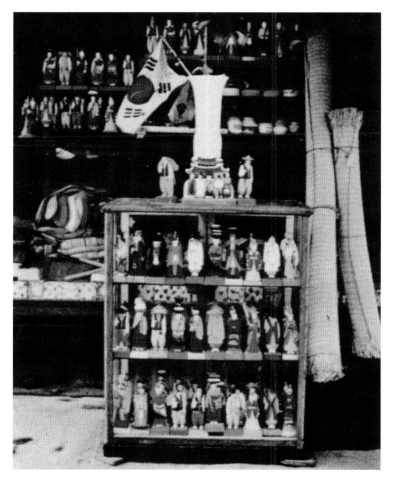

Vendor stall featuring Korean figurines (*Pictorial Korea 1955*)

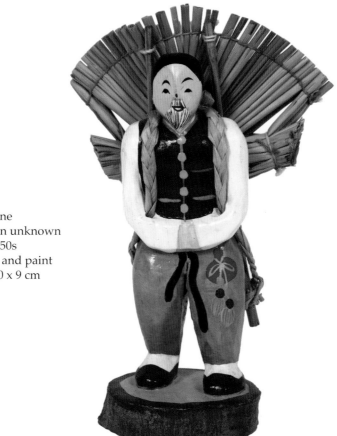

Figurine
Artisan unknown
Ca. 1950s
Wood and paint
15 x 10 x 9 cm

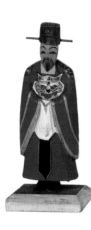

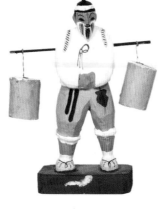

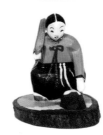

Figurine
Artisan unknown
Ca. 1950s
Wood and paint
8.5 x 7 x 7.5 cm

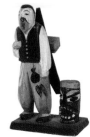

Figurine
Artisan unknown
Ca. 1950s
Wood and paint
9.5 x 5.5 x 3 cm

Figurine
Artisan unknown
Ca. 1950s
Wood and paint
17.7 x 4.7 x 5.9 cm

Figurine
Artisan unknown
Ca. 1950s
Wood and paint
15 x 11.5 x 4 cm

Figurine
Artisan unknown
Ca. 1950s
Wood and paint
Base diameter: 3.6;
Height: 11.1" to "11.1 x 3.6 cm

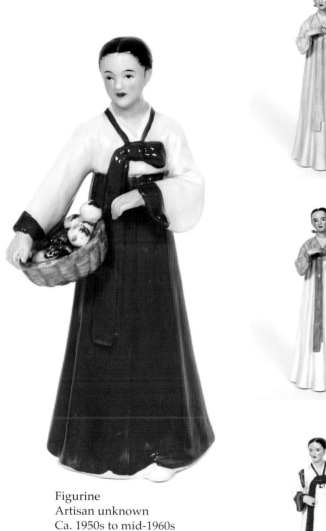

Figurine
Artisan unknown
Ca. 1950s to mid-1960s
Glazed porcelain
Height: 18.6 cm

Figurine
Artisan unknown
Ca. 1950s to mid-1960s
Glazed porcelain
Height: 23.2 cm

Figurine
Artisan unknown
Ca. 1950s to mid-1960s
Glazed porcelain
Height: 23.2 cm

Figurine
Artisan unknown
Ca. 1950s to mid-1960s
Glazed porcelain
Height: 23 cm

This set of porcelain figurines, all manufactured by the Royal Seoul ceramics company from the 1950s to mid-1960s, were most likely intended exclusively for the tourist market. Although other types of figurines sold in Korea at the time represented a variety of Korean personas, the Royal Seoul figurines appear to be exclusively court maidens in traditional *hanbok* dress. Each figurine features the Royal Seoul insignia and a model number on the bottom, indicating there were several variations on this court maiden motif. Two of the figurines have "Made in Korea" stickers on the bottom, suggesting that these figurines could have been manufactured for export to foreign markets.

EMBROIDERY

Much like the ceramic plates and figurines, the embroidery works featured here were intended for sale to foreign soldiers in Korea. The artisans depicted images of traditional culture and everyday life, like wedding days, holiday festivals, courtly life, and the story of Chunhyang and Gentleman Lee. These works combine both painting and embroidery. Paint fills in the foreground and background scenery of the images while embroidery gives images a greater sense of depth and texture. The stitching portrays hair, textiles, plants, flowers, and wood grain and is often applied in a series of straight lines, an aesthetic that could be associated with the Confucian ideal of purity and perfection.[27] The consistency in technique and design indicates that these works possibly originated from the same source. Chester Chang collected these items over the years from former soldiers who had served in Korea.

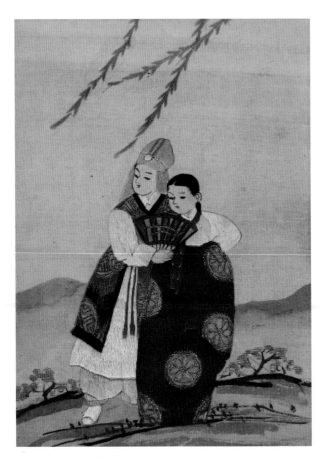

Chunhyang and Gentleman Lee
Artisan unknown
Ca. 1950s
Paint on canvas with cotton and silk embroidery
24.25 x 19.25 cm

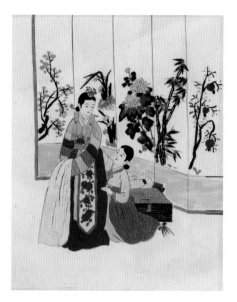

Mother and Daughter
Artisan unknown
Ca. 1950s
Paint on canvas with cotton and
silk embroidery
25.4 x 19.4 cm

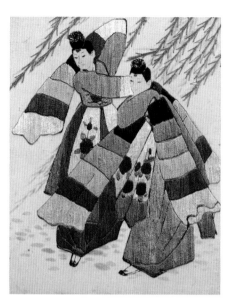

Royal Court Dancing
Artisan unknown
Ca. 1950s
Paint on canvas with cotton and
silk embroidery
25.4 x 19.4 cm

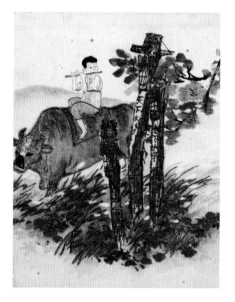

Boy on Cow Playing Flute
Artisan unknown
Ca. 1950s
Paint on canvas with cotton and
silk embroidery
25.4 x 19.4 cm

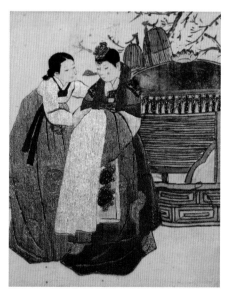

Bride with Mother
Artisan unknown
Ca. 1950s
Paint on canvas with cotton and
silk embroidery
25.4 x 19.4 cm

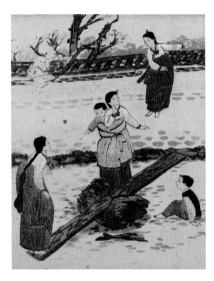

Playing *Neolttwigi* on the Lunar
New Year
Artisan unknown
Ca. 1950s
Paint on canvas with cotton and
silk embroidery
25.4 x 19.4 cm

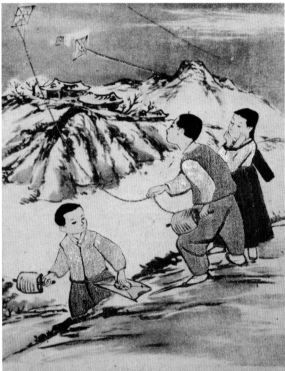

Children Flying Kites
Artisan unknown
Ca. 1950s
Paint on canvas with cotton and silk embroidery, glass
25.4 x 19.4 cm

Boy and Girl
Artisan unknown
Ca. 1950s
Paint on canvas with cotton and
silk embroidery
25.4 x 19.4 cm

ENDNOTES

[1] See examples of paintings by Korean war artists in the journal *Pictorial Korea*, published by the International Publicity League of Korea (volumes 1951-52 and 1953-54).

[2] This Lotte Gallery exhibition was recorded in contemporaneous newspaper accounts and blogs, e.g.: http://blog.naver.com/lotte2890/50178006069
http://blog.naver.com/jojako/40196580045
http://news20.busan.com/controller/newsController.jsp?newsId=20121227000001

[3] Kim 2005: 133-135

[4] Interview with Chester Chang, January 2012

[5] Roe 2001: 65

[6] Kim 2005: 178

[7] Kim 2005: 178

[8] Kim 2005: 127

[9] Kim 2001: 143

[10] Kim 2005: 130

[11] Portal 2005: 34-35

[12] Interview with Chester Chang, May 2014

[13] Roe 2001: 62

[14] Roe 2001: 63-64

[15] Interview with Chester Chang, May 2014

[16] Cho Seok-jin is also known by his artist name, Sorim.

[17] Kim 2005: 184

[18] Cho 2006: 204

[19] The three plates mentioned here are featured on pages 40, 42, and 43 of the exhibition catalog *Byeon Kwan-sik: A Utopia*, published by the National Museum of Contemporary Art, Korea (2006).

[20] Revised Romanization, also spelled Nam Koong Ryun and Namkoong Ryun.

[21] Interview with Chester Chang, May 2014

[22] International Publicity League of Korea 1955: 206

[23] Contemporary Romanization ca. 1950s, also spelled Daihan.

[24] Interview with Chester Chang, June 2014

[25] Sigong Tech and Korea Visuals 2002: 62-63

[26] Blust 2000: 532

[27] Interview with Chester Chang, June 2014

BIBLIOGRAPHY

Bain, Alan L. 2002. *Register to the Papers of Eugene I. Knez.* Washington, D.C.: National Anthropological Archives, Smithsonian Institution.

Blair, Clay. 1987. *The Forgotten War: America in Korea, 1950-1953.* New York: Times Books.

Blust, Robert. 2000. "The Origin of Dragons." *Anthropos, 95.2:* 519-536.

Chenoweth, Avery J. 2002. *Art of War: Eyewitness U.S. Combat Art from the Revolution through the Twentieth Century.* New York: Michael Friedman Publishing Group, Inc.

Cho, In-soo. 2006. "Figures in Byeon Kwan-sik's Landscape Paintings: A Wander in Modern Landscapes." In *Byeon Kwan-sik: A Utopia.* National Museum of Contemporary Art, Korea. Seoul: Culture Books.

Dowdey, Patrick, Bruce Cumings and John Kie-chiang Oh. 2003. *Living through the Forgotten War: Portrait of Korea.* Middleton, Conn.: Mansfield Freeman Center for East Asian Studies at Wesleyan University.

Heller, Francis Howard. 1977. *The Korean War: A 25-Year Perspective.* Lawrence: Regents Press of Kansas.

Houchins, Chang-su Cho. 2004. *An Ethnography of the Hermit Kingdom: The J. B. Bernadou Korean Collection, 1884-1885.* Washington, D.C.: Asian Cultural History Program.

Hoyt, Edwin Palmer. 1984. *The Pusan Perimeter: Korea, 1950.* New York: Stein and Day.

—. 1984. *On to the Yalu.* New York: Stein and Day.

International Publicity League of Korea. 1955. *Pictorial Korea 1955.* Seoul: International Publicity League of Korea.

Kang, Miongsei. 2011. "The Impact of the Korean War on the Political-Economic System of South Korea: Economic Growth and Democracy." *International Journal of Korean Studies* XV(1): 129-153.

Kim, Youngna. 2001. "Artistic Trends in Korean Painting during the 1930s." In *War, Occupation, and Creativity: Japan and East Asia, 1920-1960.* Marlene J. Mayo, J. Thomas Riner, and I. Eleanor Kerkham, eds. Honolulu: University of Hawai'i Press.

—. 2005. *20th Century Korean Art.* London: Laurence King Publishing Ltd.

Kleiner, Juergen. 2001. *Korea: A Century of Change: Economic Ideas Leading to the 21st Century — Vol. 6.* Singapore: World Scientific Publishing Co. Pte. Ltd.

Knez, Eugene I. and Chin-myong Kim. 1997. *Han ibangin ui Han'guk sarang: han Migugin ui chonmang: Han'guk munhwa chunghung ul wihan sido.* Seoul: Kungnip Chungang Pangmulgwan. [English translation of title: "The Foreigner who Loved Korea: An American's Realization of Korean Cultural Restoration"]

Korean Tourism Association. 2005. *Best of Hallyu: The Korean Wave: Open a New Era.* Seoul: Korean Tourism Association.

Klish, Renée. 2011. *Art of the American Soldier.* Washington, D.C.: Center of Military History, US Army.

Lee, S. H. 2010. 참혹한 전쟁 잊으려 일부러 자연 탐닉 '아이러니' [*Chamhokhan jeonjaeng iteuryeo ilbureo jayeon tamnik 'aireoni'*]- 부산일보 – 뉴스. http://news20.busan.com/controller/newsController.jsp?newsId=20100824000032, accessed July 2014. [English translation of title: "Ironically, Artists Purposely Indulged in Nature to Forget the War."]

Lotis, Christopher and Michel D. Lee. 2011. *Symbols of Identity: Korean Ceramics from the Collection of Chester and Wanda Chang*. Washington, D.C.: Asian Cultural History Program, Smithsonian Institution.

Matray, James I. 2011. "Beijing and the Paper Tiger: The Impact of the Korean War on Sino-American Relations." *International Journal of Korean Studies* XV(1): 155-186.

Mayo, Marlene J., J. Thomas Rimer, and H. Eleanor Kerkham, eds. 2001. *War, Occupation, and Creativity: Japan and East Asia, 1920-1960*. Honolulu: University of Hawai'I Press.

National Museum of Contemporary Art, Korea. 2006. *Byeon Kwan-sik: A Utopia*. Seoul: Culture Books.

Naval History and Heritage Command [NHHC]. n.d. *Remembering the Forgotten War: Korea, 1950-1953*. U.S. Navy Art Collection. http://www.history.navy.mil/branches/org6-7.htm, accessed July 2014.

Pash, Melinda L. 2012. *In the Shadow of the Greatest Generation*. New York: New York University Press.

Portal, Jane. 2005. *Art Under Control in North Korea*. London: Reaktion Books, Ltd.

Roe, Jae-ryung. 2001. "The Korean War and the Visual Arts." In *Remembering the 'Forgotten War': The Korean War through Literature and Art*. Philip West and Suh Ji-moon, eds. London: East Gate Books.

Sigong Tech and Korea Visuals. 2002. *Korean Cultural Heritage: Seen Through Pictures and Names, vol. 1 & 2*. Seoul: Sigong Tech Co., Ltd. & Korea Visuals Co., Ltd.

Swan, Sarah. 2011. *Korean War Art Exhibit Opens Feb. 25 at National Museum of the U.S. Air Force*. National Museum of the US Air Force. http://www.nationalmuseum.af.mil/news/ story.asp?id=123243820, accessed July 2014.

Taylor, Paul Michael and Christopher J. Lotis. 2011. *Flagship of a Fleet: A Korea Gallery Guide*. Washington, D.C.: Asian Cultural History Program, Smithsonian Institution.

Taylor, Paul Michael. 2011. "Foreword" In *Symbols of Identity: Korean Ceramics from the Collection of Chester and Wanda Chang*. Christopher Lotis and Michel D. Lee. Washington, D.C.: Asian Cultural History Program, Smithsonian Institution.

Thornber, Karen Laura. 2009. *Empire of Texts in Motion: Chinese, Korean, and Taiwanese Transculturations of Japanese Literature*. Cambridge: Cambridge University Press.

Wade, Robert. 1990. *Economic Theory and the Role of Government in East Asian Industrialization*. Princeton, N.J.: Princeton University Press.

West, Philip and Suh Ji-moon, eds. 2001. *Remembering the 'Forgotten War': The Korean War through Literature and Art*. London: East Gate Books.

Back cover images:

At right:
Mask (reverse) ▶
Artisan Unknown
Ca. 1950s
Alder wood
Dedicated to Lieutenant Colonel Savoy,
Joint Security Forces of Korea
(LTC Savoy / JSK)
27 X 20 X 11.5 cm

At left, top to bottom:
Girl on Swing, Two Girls Watching (reverse) ▶
Ca. 1950s to 1960s
Glazed ceramic plate
Manufactured by Chin Heung
Diameter: 30.7 cm

Figurine (base inscription) ▶
Artisan unknown
Ca. 1950s
Wood and paint
12.9 x 5.1 x 3.8 cm

Plate depicting 16th century Turtle Ship, ca. 1950s ▶
Artisan/manufacturer unknown
Ca. 1950s
Brass from Howitzer shell, re-cast with relief of
Yi Sun-Sin's Turtle Ship
Diameter: 34.3 cm; depth 1.9 cm

Sinseollo inscribed to Reine Voss ▶
Artisan unknown
1949
Silver
19.1 x 19.1 x 7.8 cm

Front cover images:

◀ *Early Spring Morning*
(*Choon-jo*) 춘조
Byeon Kwan-sik (1899-1976)
Ca. early 1950s
Glazed ceramic plate manufactured
by Daehan Ironstone
Diameter: 30.2 cm